A Timeline of the Civil Rights Struggle by Blacks of the Goldsboro Community and Sanford, FL & The Trailblazers That Led The Way!

By

Francis Coleman Oliver

$7.00 a copy

All proceeds from the sale of this book will go to funding the:
"Goldsboro West Side Community Historical Museum"

A Timeline Of The Civil Rights Struggle By Blacks Of The Goldsboro Community And Sanford, Florida
&
The Trailblazers That Led The Way

Special Thanks

Consultants:
Annie O'Neille, Inez Smith, Sylvester Franklin, Dr. Velma Williams, Edwards Blacksheare, and Loweman Oliver

Edited by: Tamika Knight Williams
Katheryn J. Alexander

The civil rights movement in Sanford and Seminole Country as we remember it and the role each trailblazer played.

Printed in Sanford 2010
© 2010 by Goldsboro West Side Community Historical Association

Acknowledgements:
Sylvia Drake-Izquierdo
Leia Ross, Martha Doctor for your assistance, guidance and wise suggestions on this project

Goldsboro a city founded in 1891

From 1891 to 1911, Goldsboro was a prospering city with its own government, shops, churches, and schools. Included in this bustling business district was Goldsboro's own town council, police and fire department. Goldsboro lost its identity as a city when the powerful white leaders, along with the Mayor of Sanford, Mayor Forest Lake, dissolved Goldsboro's City Charter.

~1891~1910~

Goldsboro The City

In 1891 Williams Clark, a storeowner, led 19 voters to approve the incorporation of their small Goldsboro Community as a City.

Trailblazers were:

William Walden	Mayor
J.W. Small	Clerk and Tax Collector
Joseph White	Treasurer
Williams Boykins	Post Master
Williams Clark	Marshal

1911 ~1929~

In 1921 Mount Moriah Primitive Baptist Church was destroyed by fire. The members speculated that the Ku Klux Klan set the fire in order to drive blacks from that part of the city. The land at the corner of East Eighth Street and Palmetto Avenue was sold to Holy Cross Church. The Mount Moriah congregation split into two churches the New Salem Primitive Baptist Church and the new Mount Moriah Primitive Baptist Church.

1940~1948~

Even Jackie Robinson Couldn't Integrate Sanford

Sanford got national attention when the Mayfair Inn refused to give Jackie Robinson a room during the New York Giants' spring training camp. Jackie Robinson was the first black player to sign with a major league baseball team, breaking the color barrier; however, Jackie Robinson could not break the color barrier in Sanford, Florida. The Giants later built a training camp on the corner of Mellonville Avenue and Celery Avenue. Until then, Jackie Robinson stayed in family homes on Sanford Avenue. Mr. D.C. Brock always made sure that Jackie had a nice place in Sanford to stay.

~1950'S~

Sanford Freedom Fighters Fend Off the KKK

The pioneers during this period were: Mr. D.C. Brock, Mr. Mathew James, Rev. A.A. Fields, Mr. J. H. Ward, Mr. A.W. Dingle, Mr. J. W. Noles, Mr. Thomas Wilson, Rev. McQueen, Rev. Chandler, Mr. Earl Minott Sr. Many names are forgotten, but their fight we could never forget.

One horror story of terrorizing black children in Sanford during the late 40s and the early 50's was one about "colored boys" being put in a store freezer on 13th street. From 1949 to 1951, children in Goldsboro were terrorized by a white store owners, who accused colored boys of stealing candy. When the boys ran, they would catch them and put them in the freezer. He would send someone to tell the parents that their child was in the freezer for stealing candy. The first store called the Suwannee Store, which later became the Good Luck Grocery Store. Both stores were located on 13th Street. In 1949, David Stokes and Ben Durham were two of those boys who almost froze to death in the store owner's freezer.

The actions of these mad men caused the people of Sanford to organize the NAACP. They joined forces to close the Good Luck Grocery store and get this KKK member out of the small black neighborhood known as Goldsboro. The community organized a boycott to close the store. This boycott led by a group of preachers from the different churches in Goldsboro. The leaders of the boycott were Rev. McQueen, Pastor of New Mt. Calvary; Rev. Chandler, Pastor of Allen Chapel, and the Pastor of First Shiloh; along with Mr. Matthew James, Rev. A.A. Fields, Mr. J. H. Ward, Mr. A.W. Dingle, Mr. J. W. Noles, and Mr. Thomas Wilson.

The boycott was a success. Not one black person ever went into the Good Luck Grocery Store again. The last owner of that store was a black man, Charlie Jackson. Mr. Jackson changed the store name to Tip Top Super Market.

Not In Goldsboro!
One summer night of that same year, the KKK had planned a march down 13th Street. They didn't like how the black people were meeting and getting themselves organized. The same group of leaders got their shotguns and stood at the entry of 13th Street to defend their community; however, the KKK never showed up. The KKK marched down Sanford Avenue and First Street but never marched down 13th Street or anywhere else in Goldsboro.

1951 NAACP an active organization in Sanford.

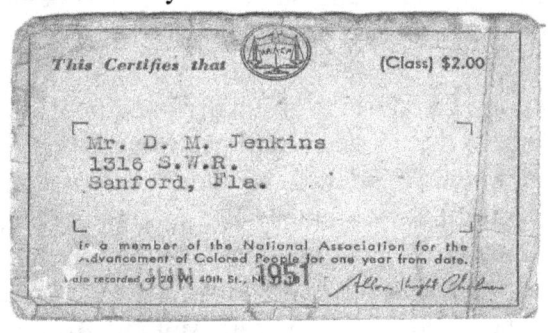

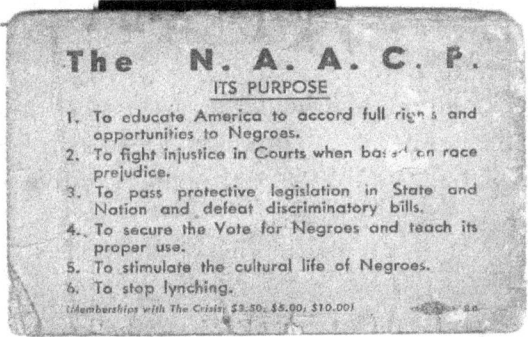

~1960'S~
Black Teens Doused with Water Hoses at Sanford Civic Center

The City of Sanford moved forward and built a lavish new civic center on the St. Johns River front. It had a big auditorium, rooms for seniors, rooms for kids, game rooms, a tennis court and beautiful landscaping on the exterior. This new recreation center was paid for by the tax dollars of all Sanford citizens. However, it was made for the enjoyment of only the white citizens in Sanford. No blacks were allowed. The Negroes had a tiny, ragtag recreation room in the public housing projects called "The Center." It was open every Friday and Saturday night for the black children to dance and hang out.

February 14, 1961- A group of young people decided it was time to dance at the new center downtown on the River Front. Some of the community leaders helped the youth to plan to integrate the new Sanford Civic Center. The community leaders gave the older teens cars so they could go to "The Center" in Goldsboro and pick up the younger teens to go downtown to integrate the civic center. Once they were out of the cars walking toward the civic center, two whites men went to a water hydrant, got out the big fire hose, and sprayed the black children with cold water.

All the children ran back to the cars and returned to the center in the project. For years, community leaders asked for a recreation center in Sanford for black children who live Sanford.

Hot Summer Days and Unrest in the 60's

The public swimming pool in Sanford closed because a black boy took a swim. The City of Sanford closed the all white public swimming pool the next day.

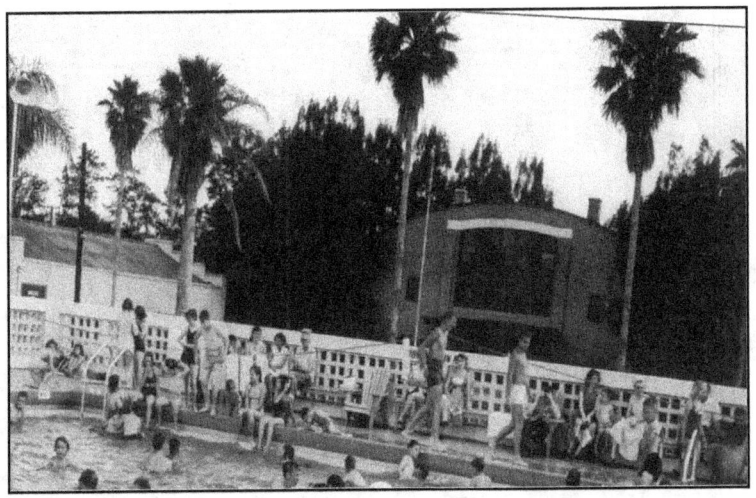

All white city pool closed because a black teen jumped in to take a swim on a hot summer day.

Led by the NAACP and **John Daniels,** Negroes came together to ask the city of Sanford for a community pool. The new pool built at the end of 18th Street, behind Goldsboro Elementary School. The dream of a new pool was short lived. The city closed the pool claiming it was costing tax payer to much to maintain.

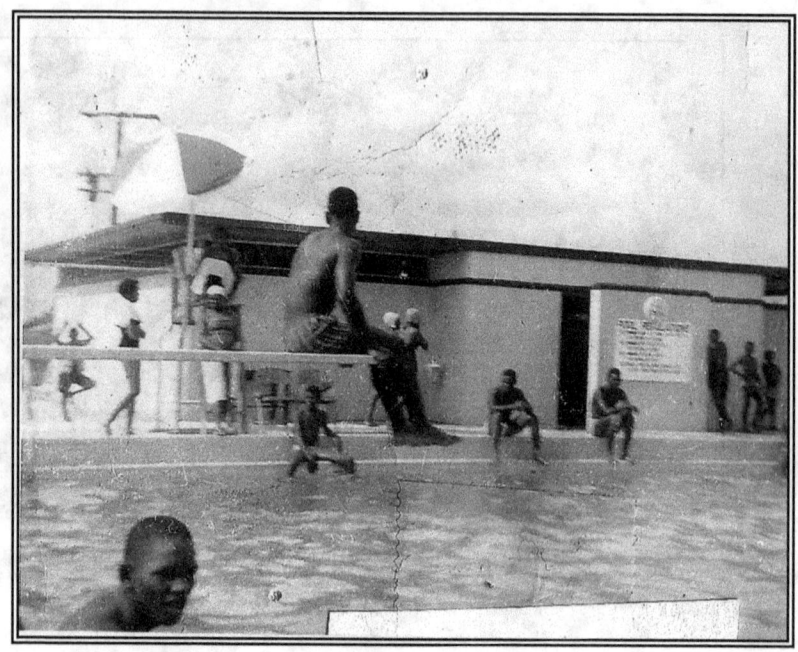

MIGRATION TO ROCHESTER, NEW YORK

Sanford did not meet the needs of many blacks. The migration to Rochester, New York was in full swing. Negroes left Sanford in droves, looking for equal opportunity and a better life up North. But leaving Sanford was no assurance of success, nor did it improve life for the ones that stayed in Sanford.

Willie Hooks (Sanford Trailblazer) a former Sanfordite and owner of a gas station and auto repair business, was among the more than 40,000 African Americans who moved to Rochester from 1950 to 1970.[5] More of them went to Rochester from Sanford, Florida than any other single location. Most worked on area farms during the harvesting season returning to Florida at the end of each season. Eventually, they "settled out" 'of the "migrant stream," and moved to Rochester, seeking a less disruptive lifestyle, year-round employment, and better opportunities for themselves and their children.

1970'S

Trailblazers Fight for Desegregation of Seminole County Public Schools

Some whites in Sanford thought they could stop integration by burning down the black schools. Enemies of the fight for freedom set the local black high school, Crooms Academy, on fire. The front of the school was replaced with a new one-story building. **Mr. Edward Blacksheare** was the principal during this time of heated racial strife and unrest.

New Trailblazers were taking the lead in Sanford: Amos Jones, Horces Orr, Jim Perry, Alfred Deladimeideiar. **Sandra Gains**, Fred and Lenora Mobley, **Francis Coleman Oliver**, Victoria and John Smith. Tommie Wilson, Velma Williams, **Willie King,** Ruthia Hester, Thelma Mike, and C.B. Pringle.

Led by President James Hagin, the NAACP was at its peak in the 70's. At the center of the struggle for equality in Sanford was **Edward Blacksheare**. Mr. Blacksheare, also a leader in the local NAACP, was tireless in his efforts to advance the cause of freedom, equal education and civil rights.

Allen Chapel AME Church was the unofficial headquarters of the local civil rights movement. Allen Chapel was the site of many NAACP fundraisers.

- Removing an unsympathetic director of the Sanford Housing Authority, Tommie Wilson was later hired).
- The Geeter Case (A black boy was accused of killing a white boy at Sanford Middle School.).
- Julian Bond came to Sanford. Whites said guns were hidden in the St. John River by the Black Panthers. They said, "Julian Bond came to stir up the colored people." No guns were found in the river.
- Most times the NAACP called special mass meetings at Allen Chapel AME Church. When issues and delicate plans were discussed, there were supplemental meetings held at the houses of leading members of the organization. Mostly, these meetings took place at the home of **Francis C. Oliver**, whose door was always open when it came to the struggle for equal rights.

The following are some of the concerns discussed and acted upon:
- 1970 desegregation plan busing black children.
- Better working conditions for city and county workers.
- More and better positions for blacks in county government and the county school system.
- Treatment of black children by white teachers in Seminole County Public Schools.

- Living conditions in the black community: unpaved streets, police brutality, etc.
- Local elections and political issues: Between Sanford and Midway, there were more than 6,000 votes, and the black vote could swing an election either way. Unfortunately, there were never enough black votes to elect a black candidate in the City or the county in the 70's.
- Roland Williams was appointed to the Seminole County School Board by the Governor in 1976.
- Joe Williams was appointed to the board in1983 and was elected by the people twice, serving two full terms and 6 months of Roland Williams last term.

Trailblazers takes on the Seminole County School Board

New trailblazers and new problems for the NAACP: Turner Clayton, Henry Sweet, Kenneth Bentley, Rev. Dr. H.D. Rucker, Bob Thomas, Bernard Mitchell, Melvin Philpot and Alvin Cummings.

To keep Crooms Academy and Goldsboro Elementary School from being closed forever, the NAACP, under the name of "Concerned Citizens," took the Seminole County School Board to court. The case was called *Martha McKinney vs. The Seminole County School Board*.

From the files of "The Concerned Citizen Task Force"

Concerned Citizens Task Force
Post Office Box 482 Sanford, Florida 32771
June 6, 1984

TO: All Churches, Social and Civic Organizations
RE: Utilization of Crooms High School

Because of the recent school board failure to carry out the consent order of the United States District Court to open the Crooms High School facility for the school term 1984-85, we find it necessary to return to court to protest.

To gain the general public awareness, education, commitment and support, we are requesting your presence as a leader to a meeting on Tuesday, June 12th, at 7:30 p.m., Crooms High School. This meeting will be designed to bring you, or someone of your organization that you may designate, up to date on the entire matter in order that you may be properly informed to advise in any capacity. This meeting will be limited to one hour. Your presence is very important to our efforts and the black community. . .Do not fail them.

From the files of "The Concerned Citizen Task Force"

Concerned Citizens Task Force
Post Office Box 482
Sanford, Florida 32771

October 24, 1984
Mr. Norris Woolfork, Attorney
738 W. Colonial Drive Orlando,
Florida 32804

Dear Sir:

At its last regular meeting on Tuesday, October 23, 1984, the body present voted unanimously to utilize legal action to activate the local School Board to carry out the court order enclosed.

We wish to engage your professional services for this case and understand that the fee is $1000.00 in the event that litigation does not extend itself. A check in this amount will be forthcoming within thirty (30) days.

If additional information is necessary, please do not hesitate to contact us.

Very truly yours,

Mrs. Martha McKinney
CHAIRMAN

IN THE UNITED STATES DISTRICT COURT FOR THE MIDDLE DISTRICT OF., FLORIDA, ORLANDO DIVISION

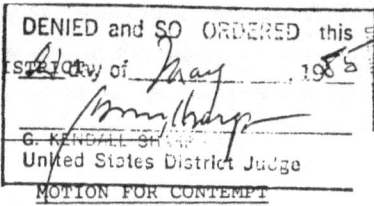

UNITED STATES OF AMERICA,
 Plaintiff,
vs. Seminole County School Board
 Defendant.
SEMINOLE COUNTY SCHOOL D

Defendants.

MARTHA, MCKINNEY, EARL C. MYERS, CALVIN COLLINS JR., WILLIE KING and BILL LEWIS, Amicus Curiae, move the Court, pursuant to Rule 71, Federal Rules of Civil Procedure, to hold the Defendant, SEMINOLE COUNTY SCHOOL DISTRICT and its Board members, in civil contempt of court, and would show that:

1. That on July 8, 1983, the said MARTHA A. MCKINNEY, EARL C. MYERS, CALVIN COLLINS, JR., WILLIE KING and BILL LEWIS, were designated amicus curiae by this Court.

2. That by consent order entered by the Court on July 29, 1983, the Defendant, SEMINOLE COUNTY SCHOOL DISTRICT, was ordered to re-open the Crooms facility as an academic facility commencing with the 1984-1985 school year.

3. That on May 16, 1984, the Defendant, at a school board meeting, voted to continue to operate the Crooms facility as an In-Service center rather than an academic facility for 1984-1985.

4. That amicus curiae orally and in writing, implored the Defendant, SEMINOLE COUNTY SCHOOL DISTRICT, to obey and comply with this Court's Order dated July 29, 1983, but the Defendant, SEMINOLE COUNTY SCHOOL DISTRICT, refused to obey this Court's Order of July 29, 1983.

5. That Defendant, SEMINOLE COUNTY SCHOOL DISTRICT, has nevertheless wholly failed and~neglected to obey, comply with
and carry out the provisions and requirements of paragraph 1 of this Court's Order and has wrongfully refused to do so.

6. The refusal of Defendant, SEMINOLE COUNTY SCHOOL DISTRICT, to obey said Order is calculated to impair, defeat,
impede and prejudice the rights of amicus curiae and others similarly situated, who, by this Court's Consent Order were
granted the right to have the Crooms facility to operate as an academic school.

WHEREFORE, Amicus Curiae.demand that the Defendant, SEMINOLE COUNTY SCHOOL DISTRICT and its members be held
in contempt of court, for its neglect and refusal to comply with and obey the Order entered herein as aforesaid,
and that the Defendant be required to show cause before this Court why it and its members should not be held in contempt of court.

Norris D. Woolfork, 111
Attorney At Law

The NAACP and "The Concerned Citizens" had a new task and that was to get a black person elected to public office. Most of the Concern Citizens that worked with the NAACP were from the Community Action government agency. Community Action was an agency funded by the US Government to help minorities in business and improve life in the black community. A major player in this group, along with Amos Jones, was **Sandra Gaines**. Sandra Gaines carried the banner for a "Single Member District" electoral system. This system made it possible for blacks to be elected to office. The following victories came out of this fight:

- The community won Single Member District after a yearlong fight.
- Sanford black community could now get a black person to the city commission.
- Robert "Bob" Thomas was the first black man to win a city commission seat in Sanford.
- 1970 desegregation plan, redistricting, and busing black children in Seminole County Public Schools.

Robert "Bob" Thomas in **1964** was the first black ever elected a Sanford' City Commissioner's seat.

In **1996** Bob Thomas ran for Mayor of Sanford.

Taken from the Sanford Herald Dec. 8, 1996

SANFORD - Bob Thomas, the top vote getter in the primary election - 1,045 to 876 by runner up Larry Dale - not only is trying to hold this edge but at the same time cope with racial lines being drawn into his quest to be Sanford's mayor. Thomas says he has received hate calls from' those who do not want him to succeed.

"All I ask is to be judged on my character not on the color of my skin," Thomas said.

Having risen from a life of poverty in the Depression (his dad earned 25 cents an hour in Sanford's orange groves and celery fields), Thomas today has a bonafide chance at age 71 to be the city's first black mayor.

That Sanford is - and has long been -racially divided, is something Bob Thomas certainly understands and desires to change. "We have not had the ugly problems they do in some cities but the truth is that whites and blacks in Sanford have always kept to their own place, he said. "This must change, if we are truly to grow into the village it should be."

~1990'S~
The Struggle Continues

By the 1990s, the NAACP had placed "The Concerned Citizens" under its umbrella because anyone could be a concerned citizen. However, not all citizens were members of the NAACP. Accomplishments of the two groups:
- 1970 desegregation plan: What to do with Black Children?
- Dr. Velma Williams became the first black woman to be elected to a seat on the city commission.
- Blacks filed complaints against a Winn Dixie grocery store that was located on Airport Boulevard near the black community. The blacks that this store was to serve complained of profiling, discrimination and harassment by store management. **Francis Oliver** was arrested for not leaving the store in protest against the discriminatory store policies. The NAACP negotiated a list of changes, which the Winn Dixie agreed to make. This kept "The Concern Citizens" from boycotting the store in 1992. Customer grievances were addressed and working conditions got better for black employees of the store.
- Joe Dillard was appointed as Sanford's first black police chief.

Blacks files law suit against the City of Sanford

In a special session of the Sanford City Commission, a proposed settlement of the federal law suit filed by five Black residents seeking election of city officials by district was held last Friday. The tentative settlement proposed against the city would create four single-member voting districts. The settlement also proposed for the residents five city commissioners to be elected within designated areas while the mayor commissioner would run at-large. Presently, all five commissioners are elected at-large.

The Sanford city commission agreed to divide the city into four single' member voting districts in response to the class action lawsuit by the Black residents. Commissioners voted 3-to-l as they approved the plan even' though they said it was unfair because they felt threatened by the probability of an unfavorable court decision.'

In the districting proposal from the plaintiffs, the majority of voters in one of the four districts are Black while the population of another is split almost evenly. The voters and population in the two remaining districts are predominantly white. Beginning with, the 1984 elections, the city is to be divided into four districts, one of which is to be predominantly Black, the voter in each of the four districts will elect their own commissioner, one for each district.

Mayor Lee P. Moore and Commissioner David T. Farr argued in favor of the plan, although Farr unsuccessfully attempted to win support for a counter-proposal to create a seven-member commission with three at large commissioners.

The suit filed in September claimed the at-large system of electing commissioners "excluded Black representation and participation and minimizes and cancels out Black voting strength in violation of their rights. This is secured by the Voting Rights Act.

According to Alfred DeLattibeaudiere, an unsuccessful candidate for office in Sanford and one of the plaintiffs in the suit, welcomed the decision.

Dr. Velma Hayes Williams

The first woman and the first black ever elected to the Sanford's City Commission. Dr. Williams is the only black male or female to serve as Sanford's Vice Mayor.

Political Trailblazers

Seminole County School Board:
* 1974 Francis Coleman Jackson Oliver, the first black woman to seek public office in Seminole County.
* Dr. J. C. Ringling
* Roland Williams elected 1976 and served 2 terms
* Joe Williams elected and served 2 terms
* Dr. Lurlene Sweeting

Sanford City Commissioner:
* C.B. Franklin
* James Sweeting
*Alfred Delattibeaudiere
*Verdell Pugh
*Bernard Mitchell

Seminole County Commission:
* Amos Jones
*Willie C. Cummings

The "Orlando Times" a voice for Black people.

It was time said Robert " Bob" Thomas a teacher, writer, and Sanford's first Black City Commissioner said it best in many commentaries he wrote for the first Black owned community newspaper.

In the late 70's and early 80's, Bob wrote about the struggle of Blacks in Sanford and surrounding communities.

Remember when reading the commentary, they were written in a time when there was discrimination, hate and the ugliness that goes with segregation.

Bob's Commentary……..by Bob Thomas….#1
We trust that you have read the "Record"-It covers the
Black experience in America from 1619-1979.
What a tremendous struggle Black people have had, and are still having. Just reading the chronology should give added incentive to every Black sister and brother; an incentive to strive for excellence in every facet of life.

We need to voice our opinions more. We need to register and vote. We need to tell the so-called politicians, where to go when they show up in our midst only near election time. We need to separate truth from deceit. If there are any of you out there who have been delivering votes for those politicians for a few dollars, you should be ashamed of yourselves. Quit this practice immediately. If your man is not concerned about Blacks as a whole, you are defeating our purpose by aiding him.

Some of you might think: the struggle is becoming easier. Well, I have news for you. It's not! Here in Seminole County, we are contented to allow people to make decisions that adversely affect our lives. We pay taxes, but do we get in return what we should? It has been hot and humid the past several days. Our boys and girls don't have any place to swim. You people know the story of the

swimming pools. But, you stand by and not say anything. It's not fair to our children. They should have a facility 'where they can go and enjoy a cool, safe, swim.

The people on the decision making level are attempting to operate things as they were done some forty or fifty years ago. And I hate to admit it, but they are doing a pretty effective job. Please sit down and evaluate each City Commissioner, the City Manager, the Chief of Police and County Commissioner. Some twenty years or more, the City Manager said "Negroes " will never use the Civic Center." Of course; we know that statement has been crushed many times. However, his attitude is no different at this time.

When black citizens first attempted to eat at Touchton's Drug Store Lunch Counter, one of the members of the City Commissioners quickly left his place of employment to help stop blacks from sitting at the lunch counter. And of course you are aware of the head of the Police Department. As long as we act how they want us to act, we are good, but when we act differently, we are militant.

As a native of Sanford, I am prepared to voice my opinion thereof. Many things happened when I was a boy and often reflected. These things were so abundant. Therefore, I have all the right in the world to hate white people, but I don't. You see there is too much God in me. He gives me that extra source of energy that sustains me in troubled times. But it really burns me when I see certain racists and bigots continually putting us down. Of course, this can be defeated. We must continue to strive forward. Lets utilize our resources and make many more sacrifices to assure our youth a better future.

As the struggle continues, we must not become discouraged. We must work in harmony. If we do this, nothing can stop us!

Bob's Commentary........by Bob Thomas....#2
Raleigh B. Boykin, Jr.
Made Positive,
Contribution
To Sanford

We' called him "Skipper."
He loved baseball and did everything he could to promote it in Sanford. Raleigh purchased uniforms, equipment, and a bus. He named the team "The American Legion Junior Nine." During his tenure, he had some good teams. Incidentally, the fellow who pinned the "Skipper" tag on him was Lewis A. Jones, who was first baseman for the team. Jones is presently a principal of an elementary school somewhere in Maryland.

Boykin had two sons: Raleigh Jr., whom he called "Duke," and Anthony B., who is deceased. He devoted as much time as possible to them. He took them to many places and sports activities: Once, he took them to a World Heavyweight Boxing Championship tight. He always stressed moral values, the golden rule, and insisted on fair play. The fellows on the team held him in high esteem, and he is highly respected in the community.

I remember prior to World War II, when he played with the team in Sanford. He was a most humorous man who made the teams cry from laughter, with his many funny antics. Men like Boykin come along once in a lifetime. He is a very humble man.

After working several years as a brakeman for Atlantic Coast Line and Seaboard Coast Line Railroad Companies, a physical disability forced him to retire. Before the above occurred, he hung on to baseball as long as he could, umpiring high school games without compensation. This fine man influenced the lives of the fellows on the team.

To add a personal note:
Thanks, "Skipper." I appreciate everything you did for me. Words arc inadequate to express my sincere feelings. .

A reminder: President Jimmy Carter recently proclaimed the month of February as "Black History Month." Parents please take time and visit your child's school. Find out if Black History Month is being observed. If not, ask-Why?

Sanford's Black Community Loses Again #3
by Bob Thomas

Divide and conquer:
It's a tactic that continues to be successful in Sanford. Thomas Wilson III moved to the state of Arizona simply because there are those of us who continue to be our own worst enemy.
Wilson has many talents. He was an important cog in the wheel of a vehicle that could have driven this town to respectability. However, too many envious, jealous people drove him away. Wilson was extremely competent and capable at his job with the housing authority. His presence was felt in the community. He bettered workers.

It's high time for those persons who have a tendency to set themselves up as God and judge others to remember the scripture: He who is without fault, let him cast the first stone. It is so easy to sit around and criticize others without taking a good look at ourselves.

This community could have used Wilson's talents, ability and most especially, his concern for his fellow man. He was concerned particularly about our youth; about the dark future our youth face if we don't give them the support they need to succeed in this racist and capitalistic society. He was a fair man, too. Many of us, unfortunately, are not fair, and it is this lack of the ability to rise above divide-and conquer tactics that prevents us from overcoming racism and capitalism.

Other nationalities came to this country and faced racism and conquered it by forming strong cohesive alliances. That is the sort of thing our former housing authority Executive Director wanted for blacks in Sanford. He wanted us to earn what we own. He wanted us to be in a position of being able to earn what is due to us. And I for one will remember him as a person who worked so that Blacks could achieve their rightful place in society.

BOB'S COMMENTARYWill We Ever? ...#4

One of the most crushing experiences I have ever had happened when I was driving an ice truck for a brother. He said: "I asked a fellow why he did not get his ice from me. The fellow's reply was, "Man, I tell you the truth, that White man's ice lasts much longer than yours.'"

This is not a joke; it really happened.

Now, ice doesn't, of course, melt faster or slower according to the race of the man who handles it. The point here is that hard as this may be to believe, the fellow really thought it would. He was ready to believe it because he was so suspicious of his brother. He would have believed almost anything bad about him; no matter how ludicrous.

As to why we are so suspicious and envious of each other, it is because of a subtle "divide and conquer" tactic that's being used by our adversaries against us. It is an effective tactic, too; it makes it almost impossible for us to work together to accomplish anything.

Here's another example of the results of such tactics: Some of our elderly will not register to vote because they think somehow their Social security checks will be reduced or withheld or they will be called to jury duty.

Poverty in this country is usually the result of a person's unwillingness to make the necessary sacrifices to accomplish a goal. Racism is not the cause of poverty, but it does contribute to it as well as exacerbating the problems that are associated with being poor. It works like this: racism directed against Blacks causes them to believe that they are locked into a no-win, no-way out situation. Faced with racism,

Blacks become apathetic. To put it another way, they become complacent. Complacency is a way to spend one's entire life on the short end of everything. Apathy and distrust of each other both make Blacks think less of themselves and less of each other as well.

Many of us cease to identify with our Blackness and resort to hiding, as it were, by belonging to a small group of Blacks. This simply makes it more obvious that, as a whole, we are not as close-knit as we should be. We should make a point of being pro-Black by continuous example of pro-Blackness.

We all have heard the statement, "Where there is no vision, the people perish." Well some visions we may have, but the all-important one of race unity is yet to become ours.

Left to right

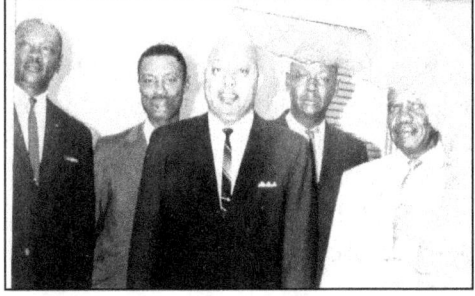

Oscar Marthie

Rufus McClain

Dr. Ringling

C.B. Pringle

Paul Dixion

Left to right

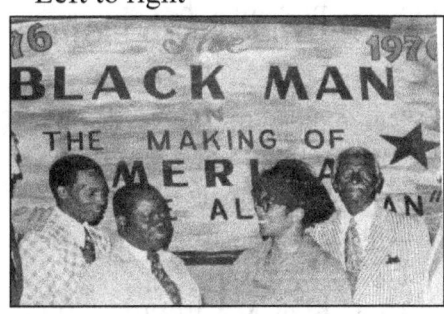

Tommie Wilson
Stan Muller
Alfreda Wallace
A.A. Fields

Rev. James Hagin, NAACP President 1970's

by Bob Thomas

Bethel A.M.E. Church Sets Example

In less than a year since its inception, the John W. Johnson Scholarship Fund of New Bethel A.M.E. Church has awarded two scholarships. Its first recipients are Donna McGill and Angela Ashley, who were completely overwhelmed by the gifts. They expressed their appreciation to the church and asked for church members to pray for them as they prepare to pursue their endeavors.

The pastor and members of this church family are to be commended for their fine Christian spirit.

The idea for the gesture came from Reginald Johnson, Co-chairman. "He came to me with the idea and I told him that it was a good one," said the Rev. Burke. The other members of the committee are: Irvin Frazier, co-chairman; Lenora Mobley, secretary; Debra Cosby, assistant secretary; and Royce Graham, treasurer. Board members are: Nathaniel Roache, Clifford Martin, John W. Johnson, E.G. Burke, Nathaniel Warren, and Freddie Mobley Sr. The Rev. M.H. Burke, pastor, is chairman of all church auxiliaries.

The scholarship fund is named after the late Brother John Johnson, who was a devoted member of New Bethel A.M.E. Church. Not only was he a dedicated trustee and member of the usher board, but he gave his all for all children in the church. For this reason, he is honored.

"His widow witnessed the festivities made some encouraging remarks, pledged her support, and thanked the church for the honor it had bestowed upon her late husband.

I told the members of the church that I would make an effort to get my church family also to sponsor a scholarship. After all, as long as the cost of education continues to rise, we must assist our young people if they are to continue up the ladder of success.

Each time I visit New Bethel, I have a strong feeling of belonging because the church is so intimate and the members show such warmth. This is the way things are supposed to be, and it certainly makes for better Christian fellowship.

It would be well if all the churches would follow the lead of this dedicated group of people. It would be doing something worthwhile, and as it has been rightly said: "Every occupation, plan, and work of man, to be truly successful, must be done under the direction of Christ, in union with his will, from love for him, and in dependence on his power."

With this in mind, we can do anything that is possible. All we have to do is develop a willingness to do whatever the task requires.

Thank you! Rev. Burke and members of New Bethel A.M.E. Church.

Trailblazers, that supported the efforts of the NAACP and The Concern Citizen Task Force, of Goldsboro and Sanford. *With out support the struggle would have been impossible:*

	Shirley W. Allen
Rev. A.A. Fields	Grace Haynes
Williams "Page" Jackson	Pearlie Mae Ford
Mannie Clark Sr.	Martha Hall Doctor
Dr. George Starke	Katie Burke
Dr. Julius Ringing	Agnes Riggins Knighten
Clifford Hurston Sr.	Clarence Fort
J.C. Scott	Mary Hayes
Joseph Jackson	Lillie Bell Merthie
JoAnna Moore	Katheyrn Alexander
Boise Stokes	Mitchell Stokes
Thomas Wilson	Carletha Merkerson
Zeke Dixon	Rufus Martin
Levi Coleman	Lelia M.Ross
Derry McGill Sr.	Wilma Coleman
J.W. Anderson	Betty Young
Willie Sutton	Arthur Hayes
Annie Clyde Walker	Victor Dargan
Thelma Franklin	Ezell G. Ashley-Smith
Leroy McClendon	Mamie Dinah
Herman Refoe	Lemuel Stallworth
Oscar Merthie Sr.	James Baskerville
Aaron Wilson	Kenneth Freeman
Marie Francis	Edgar Williams
Clifford "C.B. Pringle	Dewey Smith
Mother Ruby Wilson	Emma Mathews
Rev. Robert Doctor	Sylvester Franklin
Thelma Mike	Dr. Willie B.Sherman
Benny Joseph	Eunice Wilson
Bennie Alexander	Jack Jackson
Richard Evens	Gordon Fort
Altermese Bentley	Jean Brown
Williams "Pocket " Brown	Marva Hawkins
Alfreda Wallace	Neda Boykin
Rev. Hezekiah Ross	George Duncan
Juanita G. Harold	Sarah Floyd
Rebecca Sweet	Doris Thomas
Johnny Singleton	Annie S, O'Neille
Rufus Brooks	Frank "Sonny" Cupper
Elmira Fields	Mildred Wilson
Jeanette C. Holloway	Estella Peterson
Mary Stringer	Patricia J. Hudley
Freddie Barrington	Ella Jean Gilmore

Cont.

Dorothy T. Webster
Ingrid B. Nathan
Ronald Nathan
Oscar Merthie Jr.
Yvonne Brooks
Rev. Ben Adams
David Koster
Pastor Ronald Merthie
Jim Robison
Freddie Williams
Cleve Gipson
Henry Debose
Charlie Morgan
Johnny Joseph
Sandra McKinney Duval
Cynthia Kendrick
Robert Lee Scott
Eloise George
Atty. James Golden
Dr. Sharon Patterson
Queen E. Jones
Judge James Perry
Patsy Guy
Henry Talton
Sylvia Drake Izquierdo
Agnes T. Wade
Bernice V. King
Dr. Lou Charles Harold
Rev. Leonard Wilson
Shirley G. Williams
Victoria N. Murphy
Katie Scott
Ruby Nathan
Hilda Bass
Barbara K. Bentley
Betty Robinson
Sylvia Bodison
Patricia Sherman
Cynthia Holt Miller
Gail Ford-McQueen
Grace Milton

Mary Debose
Charles Elberry
Bernard Hudley
Earl C. Myers
Rev. Israel Black
Carolyn B. Wiggins
Henry Brown
Phyllis Richardson
Mary Buckner
Wynell F. Washington
Roosevelt Cummings
James Bradwell
Algerine Miller
Juanita A. Golden
Algerine Bradwell Paris
Mother Blanch Bell
Rebecca Henderson
Cheryl S. Clayton
Jimmy Debose
Arthur Mae Scott
Claudia Holloway
Patricia M. Whatley
Bruce Scott
Emma C. Encarcion
Irna M, Walker
Margaret D. Oliver
Lowman J. Oliver II
Yvonne Grey
Robert Guy

Debra Coleman
Grace Milton
Elaine Crumity
Rev. Grady Robinson

The Town of Goldsboro

Orange County Records
Plat Book C, page 93
Dated Mar. ... 1894
Filed Apr. 4, 1894

Plat Book 1, page 71
Seminole County Records

Plat

of

Town of Goldsboro

Plat

Map of Subdivisions of

Block G, K, & J,

Town of Goldsboro,

Orange County, Florida

Owned by A. D. Chappell.

Surveyed & Drawn by

H. C. Miller, March, 1894.

Scale 1 inch - 100 ft.

Shows land in Caption located in $NE\frac{1}{4}$ of $NW\frac{1}{4}$ of $NW\frac{1}{4}$ of Sec. 36, Tp. 19, S., R. 30 E.
...and other lands.

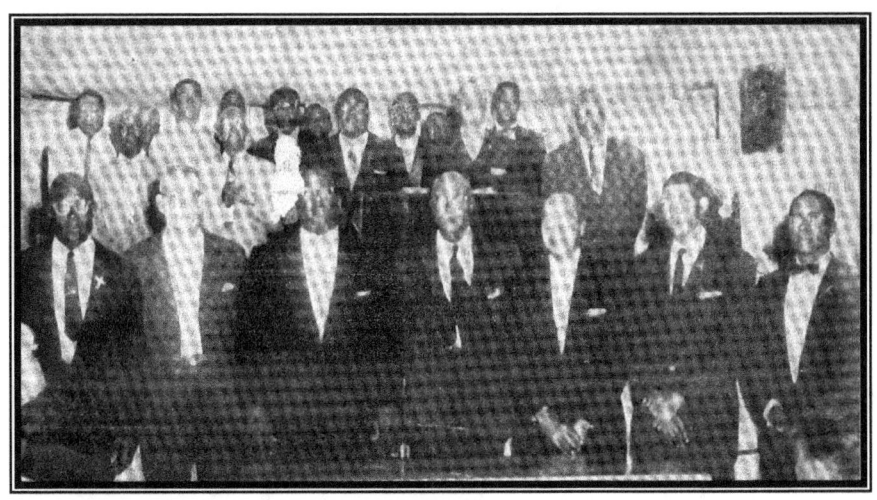

Unsung Trailblazers

Thank You for Supporting the:

"The Goldsboro Westside Community Historical Museum"

Please Read:

"Going North"
The book is about Alice Mathis, a young woman who traveled from **Sanford** to **Rochester** for many years as a seasonal worker.

www.ingramcontent.com/pod-product-compliance
Lightning Source LLC
Chambersburg PA
CBHW071832200526
45169CB00018B/1377